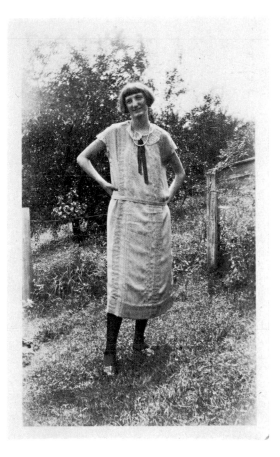

MAIRA KALMAN

DANIEL HANDLER

GIRLS STANDING ON LAWNS

Series Editor
Sarah Hermanson Meister

The Museum of Modern Art
New York

One morning
we found some photographs.
One morning
these girls stood on lawns.
We looked at the pictures,
and we got to work.

There's no use standing around.
You should do something.

This is the whole thing.

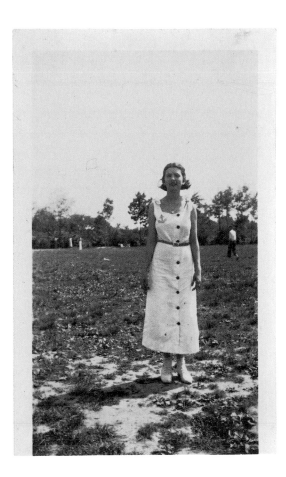

5

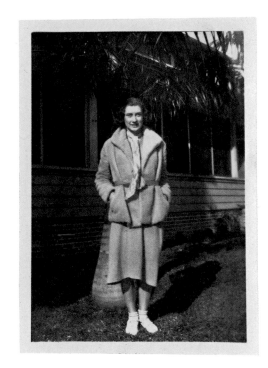

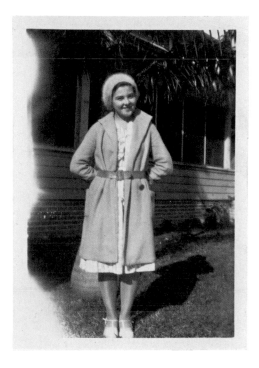

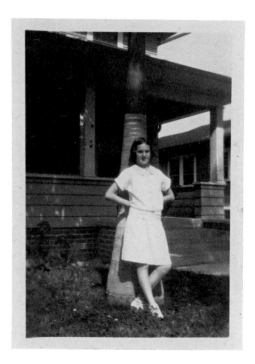

Someone has asked us to
do this, but we can say no.

But why say no?

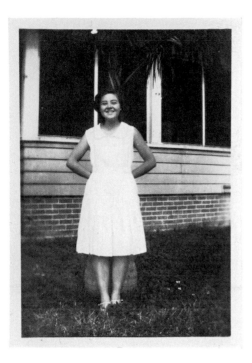

We want to stand where
we are standing.
We want to, or we would not
be standing here.

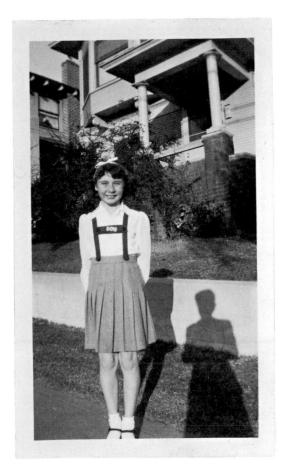

11

Meet me on the lawn,
I want to take
a picture of you.

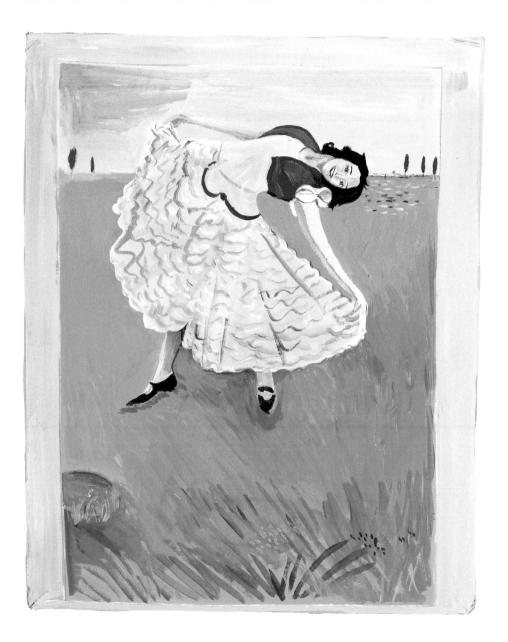

Her sister asked her, maybe.
I am making things up. A brother,
a sweetheart. He told her how
pretty she looks there on the lawn.

He's not in the picture now.

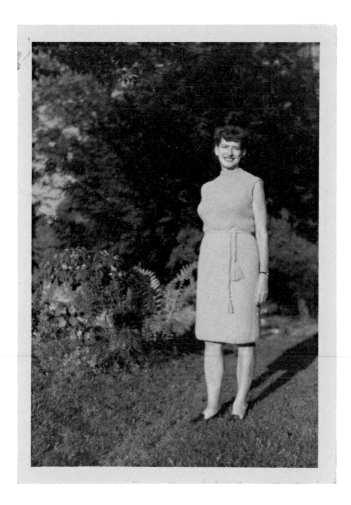

Because I didn't want
to ruin my shoes, is why.

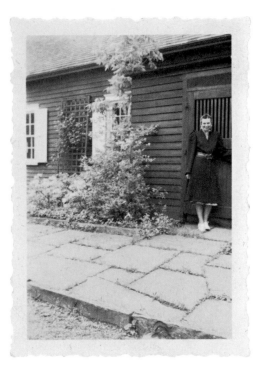

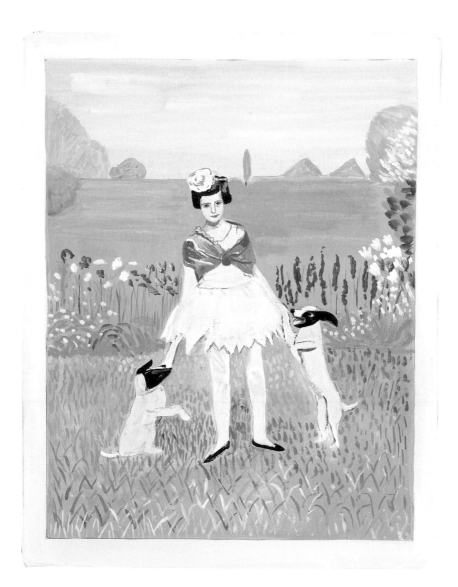

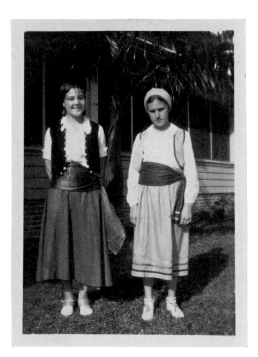

You are not
in a costume.
You are.
You are all dressed up.
We are all standing here
dressed up.

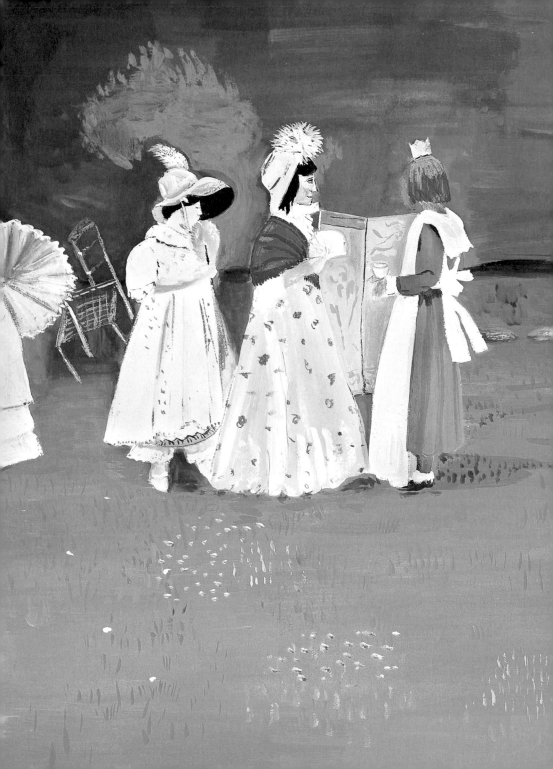

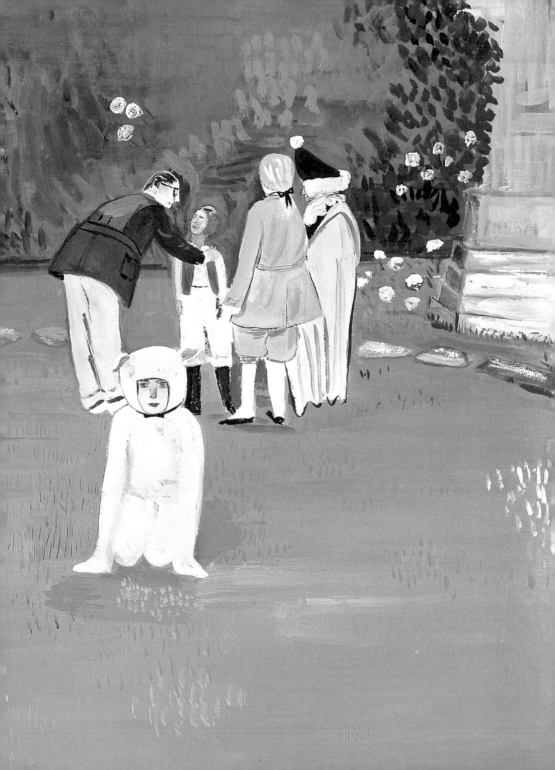

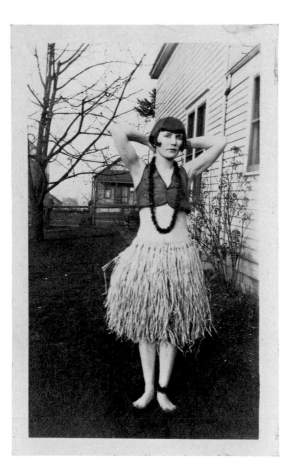

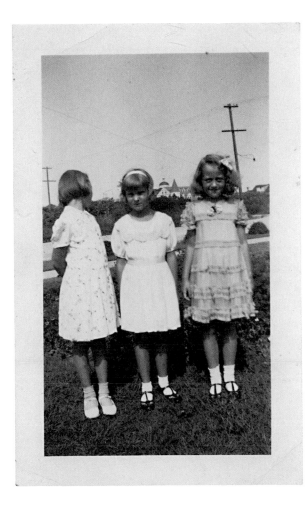

25

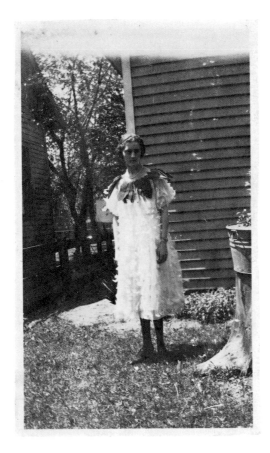

A painting, a photograph,
a sentence, a pose.
Keep track of this.
You will not remember
every place you have stood.

A picture will last longer.
There will come a time when
you can't believe it's you
standing on that lawn.

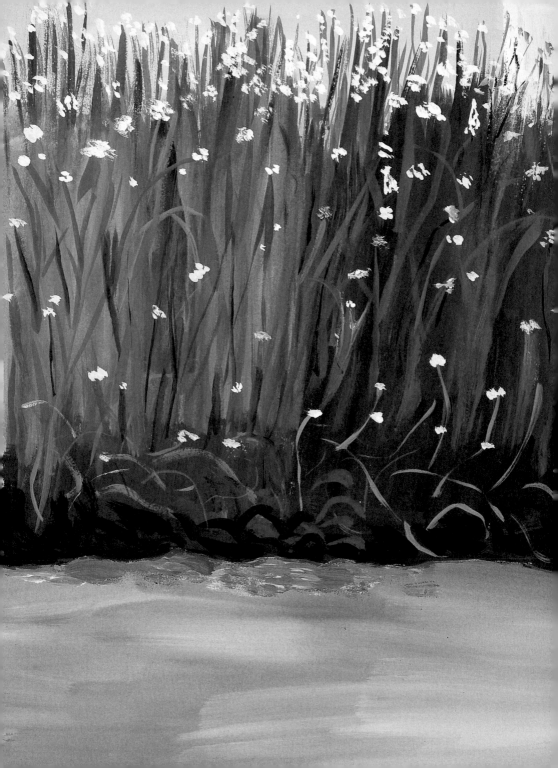

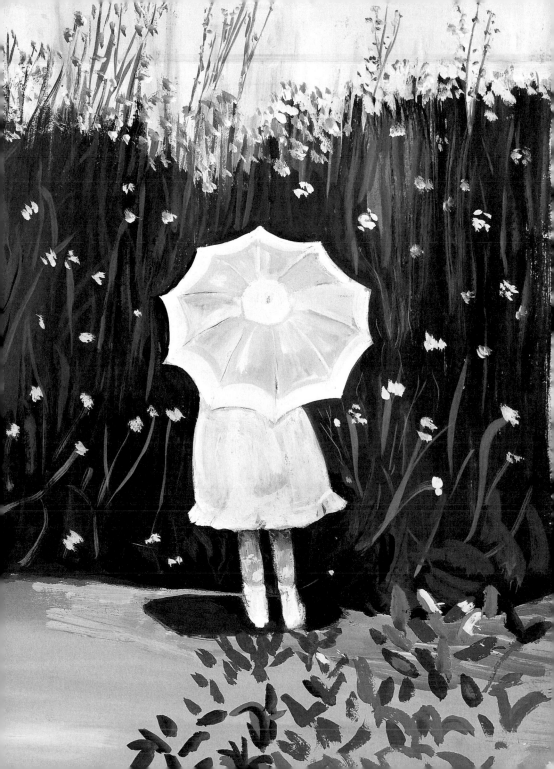

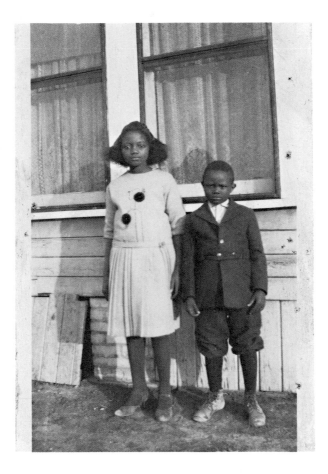

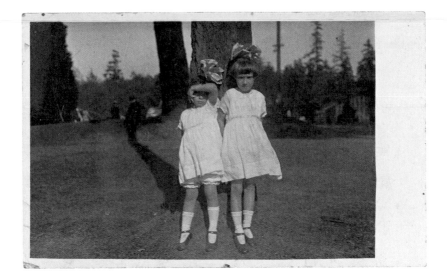

We are all gone from here.
None of this is there,
not anymore.
And yet we are still standing.

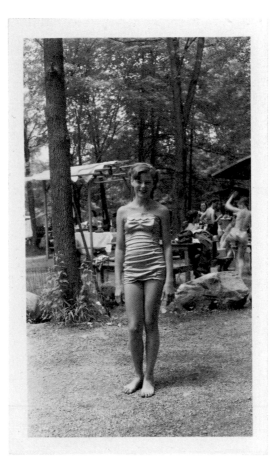

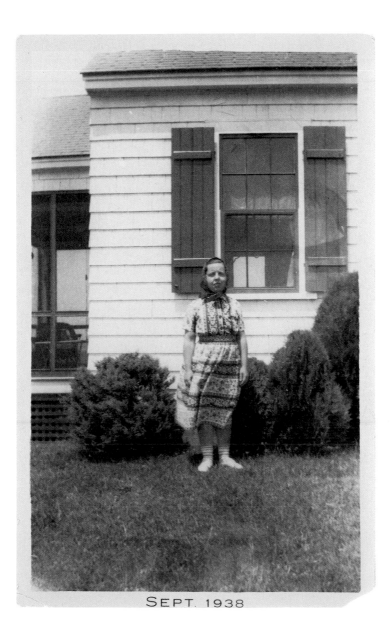

SEPT. 1938

33

Perhaps she stood there
so that she could stand still.

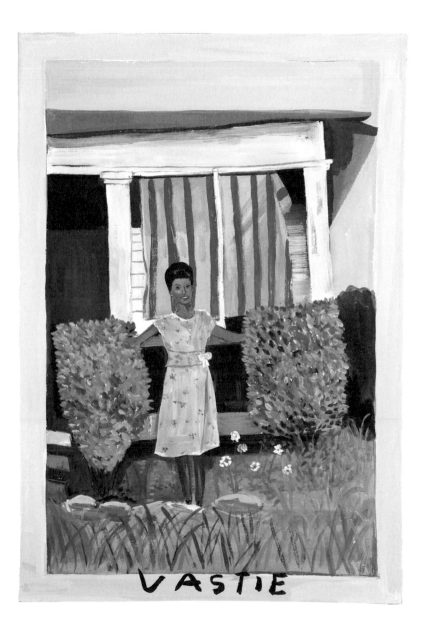

My whole life I have not known
where to put my hands.

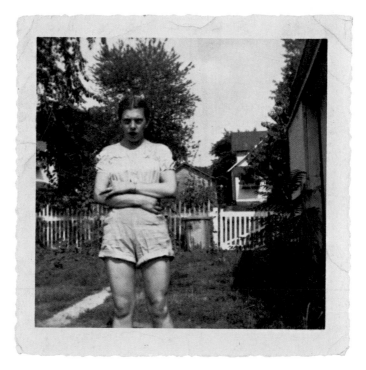

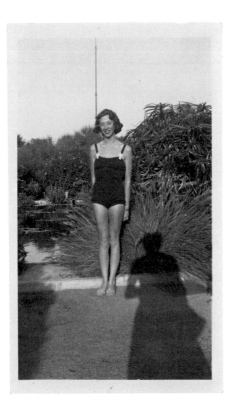

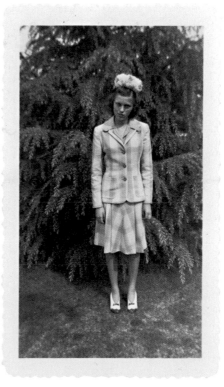

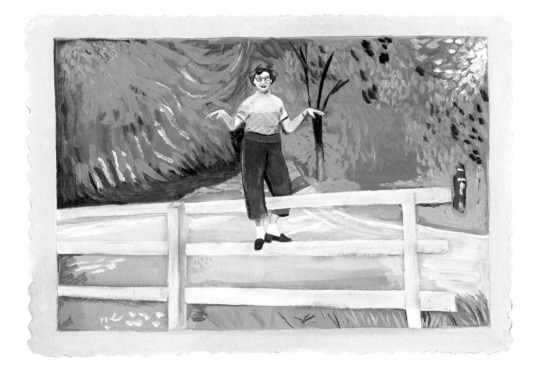

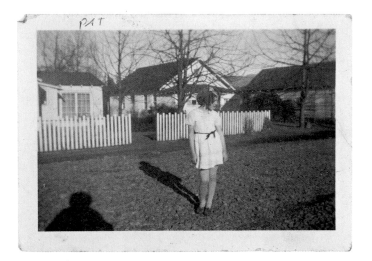

We believe this, there is nothing
else we believe more at
this moment, that we should
be standing here.

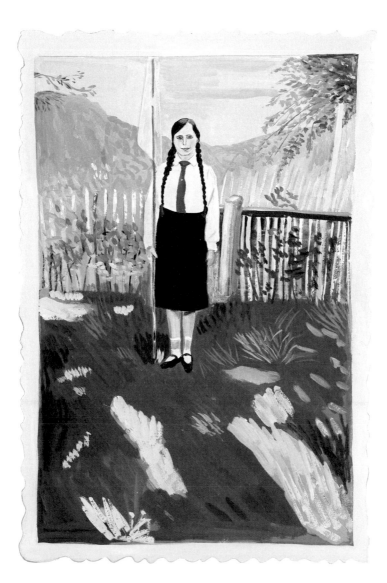

We are all standing for something on this lawn.

You don't have to be self-conscious.
We're all fools.

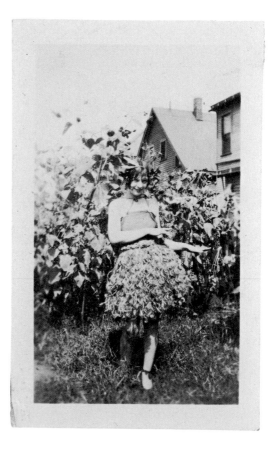

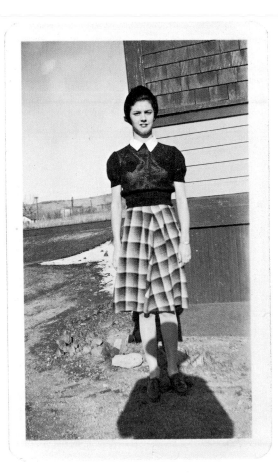

We're all, all of us, very foolish
people standing around.

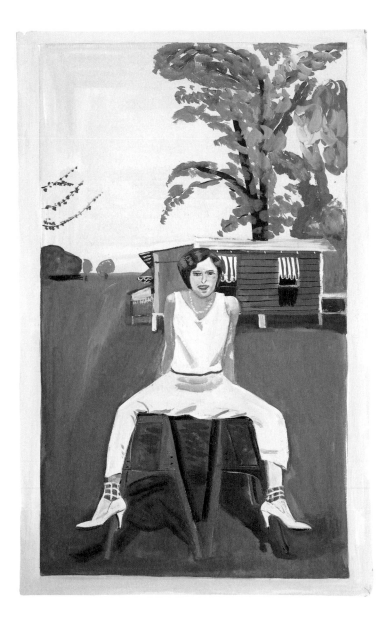

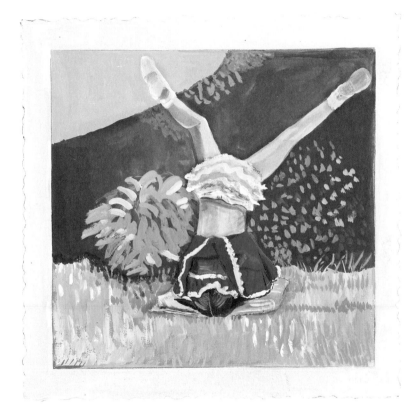

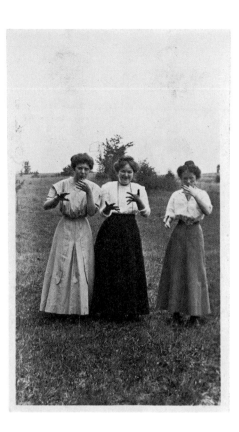

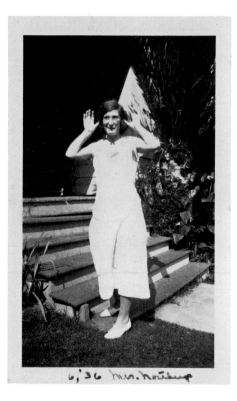

6,'36 Mrs. Northup

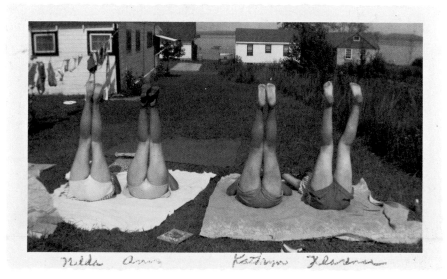

Nida Ann Kathryn Florence

It doesn't have to be a lawn, even.
It doesn't matter. Something else.

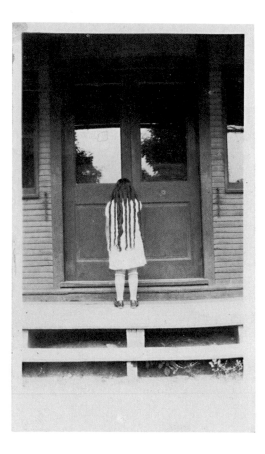

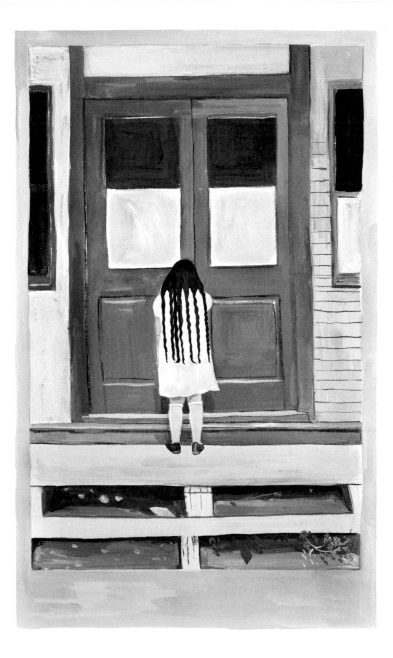

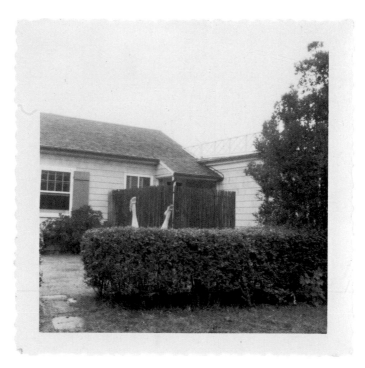

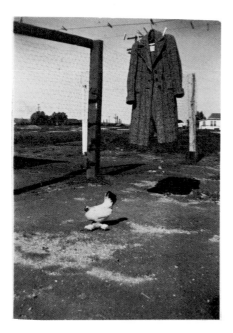

You could always do
something else.

Stand for something,
stand for something!

Otherwise what do
you stand for,
why are you even standing?

This is the whole thing,
and then it's done.

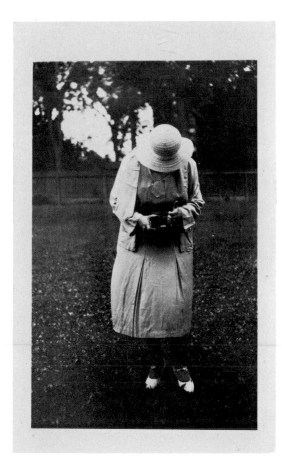

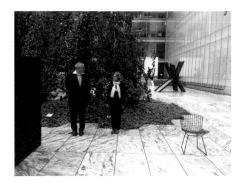

I met Daniel in Bologna, not far from the Morandi museum.
Giorgio Morandi lived his entire life with his two sisters.
I imagine that at some point, his sisters stood on the lawn
and were photographed by someone, as were my mother, my
sister, my cousin, me, and every girl I ever knew.

I stood on the lawn and was so proud and self-confident that
thinking of it gives me a jolt of happiness.

Daniel was not there to see it, but in fact, he was. —M. K.

Growing up, my house had two lawns. One lawn was for
playing and taking pictures. My parents planted a tree
when I was born and a tree when my sister was born and we
would take pictures when we remembered, standing
in front of our trees. My sister's tree flourished and mine
died early.

The other lawn was for nothing.

Every meal with Maira is like a picnic. —D. H.

The Museum of Modern Art was founded in 1929—just around the time that many of the snapshots that appear in this book were made (although it's often not possible to know precisely who made them, or where, or when). Within a few years the Museum started adding photographs to its collection, and in December 1940 these were gathered together and trusted to the care of the newly formed

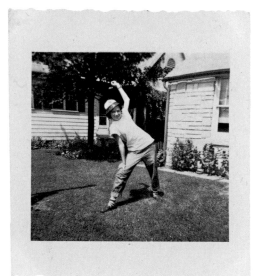

Department of Photography. Today there are more than twenty-five thousand photographs in MoMA's collection, which includes masterpieces by leading artists from the 1840s to the present as well as a generous selection of photographs that were never intended to be works of art, made by untrained amateurs, seasoned professionals, journalists, scientists, and commercial studios.

There is a neat name for this messy diversity of objects created without artistic ambition: vernacular photography. And since the introduction of George Eastman's Kodak No. 1 camera in 1888 (with its now-legendary advertising slogan, "You Press the Button—We Do the Rest"), the snapshot has become the most popular subcategory of vernacular photography— particularly if one considers the millions of digital images on Instagram, Flickr, and Facebook as descendants of the

film-based variety. MoMA's collection is as diverse as photography itself, revealing the ways in which photography's history as a fine art is inextricably linked to its vernacular traditions. The ubiquity of photography, the near impossibility of finding a person who has not held in his or her hand a snapshot similar to the ones reproduced on these pages, has been a source of both irritation and inspiration for those seeking to secure photography's status among the fine arts. In no other medium are the boundaries between artist, amateur, and professional for hire so blurred, making it foolish to attempt to understand one without the others.

Girls Standing on Lawns—the first in a series of collaborations between Maira Kalman, Daniel Handler, and the Museum—emerged from a shared fascination with anonymous snapshots and the stories they suggest. The images in this book, as well as the ones that inspired Kalman's paintings, are drawn from MoMA's collection, and specific information about each one appears on pages 60 and 61. Future books in this series will continue to use photographs—vernacular ones and perhaps even some made as art—from the collection as points of departure. We hope you enjoy them all.

Sarah Hermanson Meister
Curator, Department of Photography
The Museum of Modern Art, New York

The Photographs

Cover and page 1
Untitled. c. 1930
4 1/16 × 2 3/8"
(10.3 × 6.1 cm)
Gift of Peter J. Cohen

Page 5
Agnes Hambrick.
c. 1950
4 3/16 × 2 3/8"
(10.6 × 6 cm)
Gift of Peter J. Cohen

Page 6
Untitled. c. 1940
3 1/8 × 2 1/4" (8 × 5.7 cm)
Gift of Maira Kalman

Page 7
Untitled. c. 1940
3 3/16 × 2 1/8"
(8.1 × 5.5 cm)
Gift of Maira Kalman

Page 8
Untitled. c. 1940
3 3/16 × 2 1/8"
(8.1 × 5.5 cm)
Gift of Maira Kalman

Page 9
Untitled. c. 1940
3 3/16 × 2 3/16"
(8.1 × 5.6 cm)
Gift of Maira Kalman

Page 11
Untitled. c. 1950
4 1/8 × 2 5/16"
(10.5 × 5.9 cm)
Gift of Jeffrey Fraenkel

Page 13

Untitled. c. 1940
3 1/4 × 2 1/4"
(8.3 × 5.7 cm)
Gift of Peter J. Cohen

Page 15
Untitled. c. 1965
Chromogenic color
print, 4 5/8 × 3 1/8"
(11.7 × 7.9 cm)
Gift of Peter J. Cohen

Page 16
Untitled. c. 1950
3 1/8 × 2 1/8" (8 × 5.4 cm)
Gift of Maira Kalman

Page 19

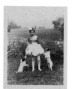

Untitled. c. 1920
4 × 3 3/16"
(10.1 × 7.7 cm)
Gift of Peter J. Cohen

Page 20
Untitled. c. 1940
3 1/8 × 2 1/8" (8 × 5.5 cm)
Gift of Maira Kalman

Page 22–23

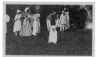

Untitled. c. 1930
3 1/16 × 5 5/16"
(7.8 × 13.5 cm)
Gift of Peter J. Cohen

Page 24
Untitled. c. 1950
4 1/8 × 2 3/8"
(10.5 × 6.1 cm)
Gift of Peter J. Cohen

Page 25
Untitled. c. 1950
4 3/16 × 2 3/8"
(10.6 × 6 cm)
Gift of Peter J. Cohen

Page 26
Untitled. c. 1930
4 1/8 × 2 3/8" (10.4 × 6 cm)
Gift of Peter J. Cohen

Page 28–29

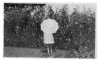

Untitled. c. 1920
2 5/16 × 4"
(5.9 × 10.1 cm)
Gift of Peter J. Cohen

Page 30
Untitled. c. 1930
4 1/2 × 2 3/4"
(11.4 × 7 cm)
Gift of Peter J. Cohen

Page 31
Untitled. c. 1910
3 1/8 × 4 5/8" (8 × 11.7 cm)
Gift of Peter J. Cohen

Page 32
Untitled. c. 1940
4 3/16 × 2 3/8"
(10.6 × 6 cm)
Gift of Peter J. Cohen

Page 33
Untitled. September
1938
5 5/16 × 3 7/16"
(14.2 × 8.7 cm)
Gift of Peter J. Cohen

Page 35

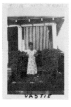

Vastic. c. 1955
4½ × 2¹⁵⁄₁₆"
(11.5 × 7.5 cm)
Gift of Peter J. Cohen

Page 36
Untitled. c. 1955
3 × 3" (7.6 × 7.6 cm)
Gift of Peter J. Cohen

Page 37, left
Untitled. c. 1950
4⅛ × 2⅜" (10.5 × 6 cm)
Gift of Jeffrey Fraenkel
right
Joane. c. 1950
4⅛ × 2⁵⁄₁₆"
(10.4 × 5.8 cm)
Gift of Peter J. Cohen

Page 38

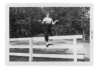

*Just Clowning
Around.* October 1952
3¹⁄₁₆ × 4⁷⁄₁₆"
(7.7 × 11.3 cm)
Gift of Peter J. Cohen

Page 40
Pat. c. 1935
2¹⁄₁₆ × 3⅛"
(5.3 × 7.9 cm)
Gift of Peter J. Cohen

Page 41

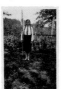

Untitled. c. 1940
3⅛ × 2¹⁄₁₆" (8 × 5.3 cm)
Gift of Peter J. Cohen

Page 44
Untitled. c. 1930
3¾ × 2³⁄₁₆"
(9.6 × 5.5 cm)
Gift of Peter J. Cohen

Page 45
*Leta, the day she left
for Lex.* February 1943
4⅛ × 2⁵⁄₁₆"
(10.5 × 5.9 cm)
Gift of Jeffrey Fraenkel

Page 46

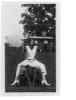

Untitled. c. 1940
4 × 2⁵⁄₁₆"
(10.2 × 5.9 cm)
Gift of Peter J. Cohen

Page 47

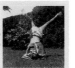

Untitled.
September 1954
3 × 3" (7.6 × 7.6 cm)
Gift of Peter J. Cohen

Page 48, left
Mrs. Northup. 1936
4¹⁄₁₆ × 2⁵⁄₁₆"
(10.3 × 5.9 cm)
Gift of Peter J. Cohen
right
Untitled. c. 1900
4⅛ × 2⁵⁄₁₆"
(10.5 × 5.9 cm)
Gift of Peter J. Cohen

Page 49
*Nilda, Ann, Kathryn,
Florence.* c. 1955
3¹⁄₁₆ × 5¼"
(7.7 × 13.4 cm)
Gift of Peter J. Cohen

Page 50 and 51
Untitled. c. 1920
4⁵⁄₁₆ × 2⅜"
(10.9 × 6.1 cm)
Gift of Peter J. Cohen

Page 52
Untitled. c. 1955
3 × 3" (7.6 × 7.6 cm)
Gift of Peter J. Cohen

Page 53
Buster's Poultry Farm.
c. 1930
3⅛ × 2⅛" (8 × 5.4 cm)
Gift of Peter J. Cohen

Page 55
Untitled. c. 1920
3¹³⁄₁₆ × 2⅜" (9.7 × 6 cm)
Gift of Thomas
Walther

Page 58
Untitled. c. 1950
2¹⁄₁₆ × 2³⁄₁₆"
(5.3 × 5.6 cm)
Gift of Peter J. Cohen

Page 63
Untitled. c. 1950
3⅛ × 2¹⁄₁₆" (8 × 5.2 cm)
Gift of Peter J. Cohen

Back cover
Untitled. c. 1910
2⅜ × 4⅛"
(6.1 × 10.5 cm)
Gift of Peter J. Cohen

61

Credits

Produced by the Department of Publications
The Museum of Modern Art, New York

Edited by Chul R. Kim and Emily Hall
Designed by Beverly Joel, pulp, ink.
Production by Marc Sapir
Photograph research by Tasha Lutek
Printed and bound by Trifolio, Verona, Italy
This book is typeset in Avenir and Sentinel.
The paper is 150 gsm Magno Plus matte.

Library of Congress Control Number: 2013955186
ISBN: 978-0-87070-908-1

Distributed in English by Abrams Books for
Young Readers, an imprint of ABRAMS, New York

Printed in Italy

Front cover: illustration by Maira Kalman;
back cover: Photographer unknown. Untitled.
c. 1910. Gelatin silver print, 2⅜ x 4⅛"
(6.1 x 10.5 cm). The Museum of Modern Art,
New York. Gift of Peter J. Cohen

All images prepared by The Museum of Modern
Art Imaging Services: David Allison: all illustrations;
John Wronn: all photographs

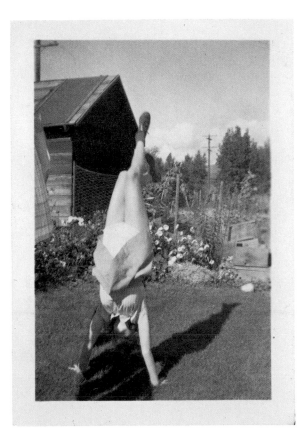